101
Glimpses of the
North Fork
AND ISLANDS

101

Glimpses of the

North Fork

AND ISLANDS

ROSEMARY McKINLEY

THE
History
PRESS

Published by The History Press
Charleston, SC 29403
www.historypress.net

Cover image: A ferryboat, circa 1900. *Courtesy of the Shelter Island Historical Society.*

First published 2009

Manufactured in the United States

ISBN 978.1.59629.657.2

Library of Congress Cataloging-in-Publication Data

McKinley, Rosemary.
101 glimpses of the North Fork and the islands / Rosemary McKinley.
p. cm.
ISBN 978-1-59629-657-2
1. North Fork (N.Y. : Peninsula)--History--Pictorial works. 2. North Fork
(N.Y. : Peninsula)--Social life and customs--Pictorial works. I. Title. II. Title:
One hundred one glimpses of the North Fork and the islands. III. Title:
One hundred and one glimpses of the North Fork and the islands.
F127.N84M34 2009
974.7'25--dc22
2009013927

Notice: The information in this book is true and complete to the best of our
knowledge. It is offered without guarantee on the part of the author or
The History Press. The author and The History Press disclaim all liability
in connection with the use of this book.

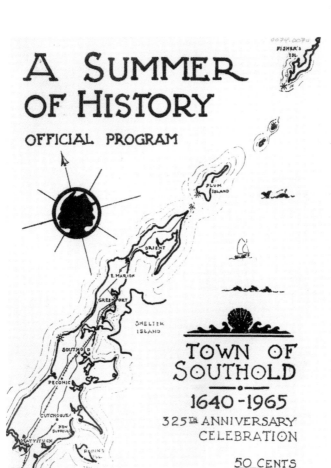

A SUMMER OF HISTORY

OFFICIAL PROGRAM

TOWN OF SOUTHOLD

1640 - 1965

325ᵀᴴ ANNIVERSARY
CELEBRATION

50 CENTS

Courtesy of Southold Town.

Serenity in Southold

It is the quiet that you hear, at first
then the birds, sweetly singing
the owl, who-who-ing
the lack of noise from the roads

I watch the white cotton-tailed rabbits
and hear the blue jays screeching
the sparrows chirping
and think of the people who came before us
to this enviable place
Some came for the fruits of the sea
Others for fertile land

Sitting at the bay
I am being calmed by the sound of the tide
sometimes rushing loudly, crashing crisply to the shore
other times tip-toeing in, soothing those of us who rush
around
in our harried world

—Rosemary McKinley

CONTENTS

Acknowledgements

I owe a debt of gratitude to several people who were invaluable in offering me their assistance in this endeavor. First and foremost, I would like to thank archivist Melissa Andruski and assistant archivist Dan McCarthy at the Whitaker Collection of the Southold Free Library for their willingness and cheerfulness in helping me delve into their collection for images and information. David van Popering, also of the Southold Free Library, was most helpful in assisting me in the technical aspects of working with the images. His technical expertise and patience are greatly appreciated. Without all three of these wonderful people, I would not have been able to complete my research.

Mary Ella Ostrosky at the Cutchogue New Suffolk Library was very helpful in finding the pictures and information on other hamlets of the North Fork. She, along with Poppy Johnson and Ann Arnold of the Floyd Memorial Library in Greenport, deserves my thanks. Geoffrey Fleming, director of the Southold Historical

ACKNOWLEDGEMENTS

Society, and Phyllis Wallace and Beverlea Walz of the Shelter Island Historical Society have also been helpful in making this process run a little smoother.

Lisa Stevenson of the Southold Indian Museum aided me in locating the up-to-date facts surrounding the Corchaug Indians and how they lived. Carol De Long and Cynthia Halsey of the Southold Presbyterian Church graciously shared photographs and history of the First Church with me. I would also like to add another person, Kate Pluhar, my editor, with whom I have been working throughout this process. She answered my many questions while giving me direction along the way. I truly appreciate all of the guidance I have received from all of these people.

INTRODUCTION

The attraction of the North Fork of Long Island has been present for close to four hundred years. This peninsula, filled with inlets, creeks and bays, drew Native Americans (Algonquians first) and later Dutch and English settlers from across the sound in Connecticut because the water was rich with clams and fish. Fertile land produced an abundance of corn, beans and squash. The forests provided much timber, which was used for making dugout canoes, shipbuilding and house construction. Still later, many other immigrants, including the Irish and a large group of Polish farmers, were drawn to this area for the same reasons. African Americans migrated here to work on the farms.

Today, people from suburbia and Manhattan want to live in this last quiet, rural and somewhat preserved area. The house lots tend to be larger than their suburban counterparts, and the landscape still boasts farmland, barns and silos. Although the farm acreage has dwindled, many vineyards, sod and flower farms have taken their place.

The North Fork is celebrated for its winemaking efforts, with wineries open year-round to attract tasters, as well as encouraging tourists to visit their cultural fests. Deer, rabbits and foxes are spotted on many lawns, while in some areas horses graze in paddocks, evoking an earlier time in history. Farm stands, resplendent with freshly grown fruits and vegetables, beckon from the main road, drawing people to sample their wares from late spring to late fall. Some even continue the practice of the honor system, placing a metal box beside the produce in which one may leave payment. Even though the region is not as quiet and serene as it once was, it still emits a bucolic feeling.

The proximity to water permeates the entire area, with spectacular views painted differently in every season. The many public and private beaches and marinas—a sight to behold!—are contrasted with the rugged bluffs of Long Island Sound and the peaceful calmness of Peconic Bay. That richness can be seen from almost any vantage point because there are so many beaches. The islands of the North Fork also speak to this peaceful mindset.

Shelter Island, the largest, with eight thousand acres, is located at the tip of Long Island between the North and South Forks and is accessible by ferry or by private boat. It has a very rural feel, with no box stores and a few mom and pop establishments for the convenience of the year-round and summer residents. Close to one-third of the island is protected by the Nature Conservancy's Mashomack Preserve, which reinforces the pastoral experience. Over one hundred

years ago, it was a farm community with some fish factories. Then, summer visitors realized the resort potential and built many inns and hotels to accommodate this venture. Seascape scenes are in full view around every corner.

Many of the other islands are not open to the public for a variety of reasons; however, all of them can be viewed by water from small boats. Great Gull Island was once a military post, guarding approaches to Long Island. Now, the American Museum of Natural History uses it as a bird sanctuary. Little Gull Island is twelve hundred feet off East Hampton and is also used by the American Museum of Natural History. Both are uninhabited by humans.

Gardiners Island, with 3,318 acres, has been family owned for close to four hundred years. The English called it the Isle of Wight. It is the oldest family-owned real estate in the United States and is closed to the public.

Robins Island, a 435-acre tract of land, has had several private owners over the years—Ira Tuthill, Joseph Krupski and John MacKay, to name a few. It is now owned by Louis Bacon, a financier from North Carolina. He worked with the Nature Conservancy to set up a conservation easement to keep the island from being developed in the future. In the past, it was used as a private game preserve for hunting and fishing and still is today.

Plum Island, formerly known as Fort Terry, a United States military establishment from 1879 to 1948, is an 840-acre island. It is shaped like a pork chop and is located about two miles off the North Fork. Now it is closed to the public, and

it has been used as a federal facility for animal research since 1954. It is accessible by government ferry only.

Fishers Island, at thirty-two hundred acres, was established as Fort H.G. Wright in 1898 and later became a Coast Guard installation. In World Wars I and II, it served as a coastal defense project to protect the Northeast. Geographically, it is closer to Connecticut and can be reached by ferry from New London. It has been part of New York State and Southold Town since 1879. Today, it is inhabited by a small year-round population that swells to many more in the summer months.

WATER, WATER, EVERYWHERE

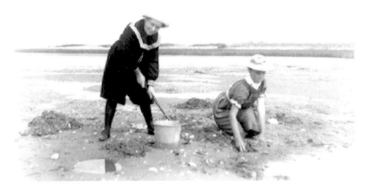

Helen and Alice Parker clamming in Coecles Harbor on Shelter Island. Clamming was a good way to pass the time on a warm summer day and bring home dinner as well. *Courtesy of the Shelter Island Historical Society.*

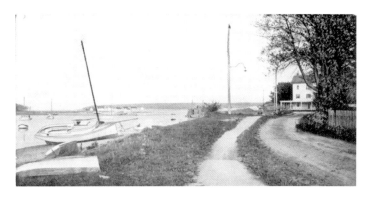

This postcard of Stirling Street, Greenport, offers an inkling of the beauty of the sailboats waiting to be used and a shot of Shelter Island in the distance. Stirling Basin provided anchorage and winter resort for many pleasure and commercial boats. In its early history, the area consisted of two settlements: Stirling, which was to the north, near Route 48; and Green Hill, which overlooked the harbor. In 1838, they were combined to become the hamlet of Greenport. *Courtesy of the Southold Historical Society.*

Water, Water, Everywhere

Waterfront, Orient, Long Island, circa 1917. This image provides a view of Orient along Long Beach Bay. The town was originally called Oysterponds because of the abundance of shellfish. In 1838, the name was changed to Orient, the most eastern point of Long Island. *Courtesy of the Southold Historical Society.*

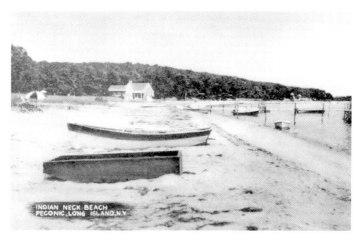

Indian Neck Beach, Peconic, Long Island. This postcard depicts a typical summer scene, with rowboats casually pulled up on the beach at Richmond Creek. Private homes and waterfront surround this spot, but today there is a Southold town ramp available for launching boats. *Courtesy of the Cutchogue New Suffolk Library.*

Water, Water, Everywhere

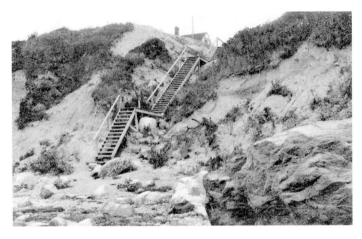

Sixty-seven Steps, Greenport, Long Island. Due to the height of the cliffs, many residents needed steps to give them access to Long Island Sound. Similar sites may be found up and down the northern coast of the sound. *Courtesy of the Cutchogue New Suffolk Library.*

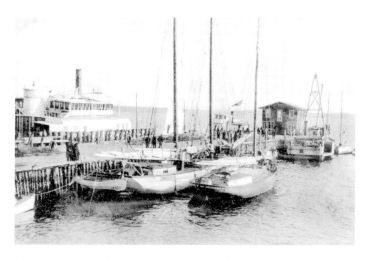

Main Street Wharf, Greenport, Long Island. This postcard shows the proximity of the town of Greenport to the harbor, where recreational, as well as commercial, boats were tied. It also served as a shipbuilding center from the 1800s through World War II, and later many yachts were overhauled and repaired here. *Courtesy of the Cutchogue New Suffolk Library.*

Water, Water, Everywhere

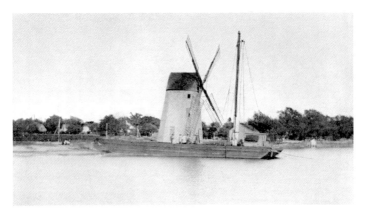

Moving a windmill from Orient, Long Island, to Glen Island. Water transportation was a faster and cheaper way to move heavy cargo. Glen Island was located on Long Island Sound, near New Rochelle in Westchester County, so it made sense to move the windmill by boat. *Courtesy of the Shelter Island Historical Society.*

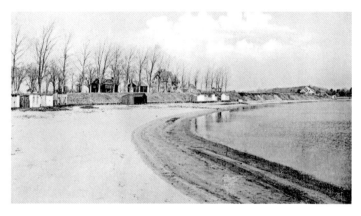

This image shows what the area near Town Harbor Road looked like in 1908, including the beach shacks built away from the water (Little Peconic Bay) for use in the summer. Today, it is privately owned. *Courtesy of the Whitaker Collection of the Southold Free Library.*

Water, Water, Everywhere

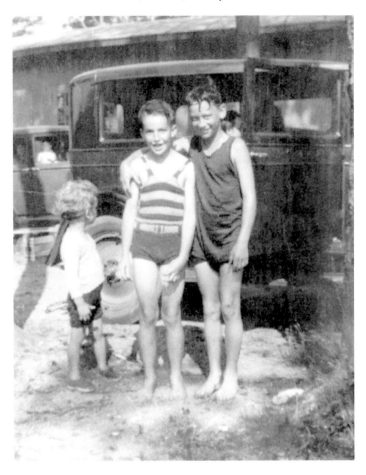

Summer fun. These boys are spending a typical summer afternoon at Oak Grove in Greenport, circa 1920. Lewis Pemberton is seen on the right. Ted Brigham is on the left. The other child is unidentified. *Courtesy of the Floyd Memorial Library, Greenport.*

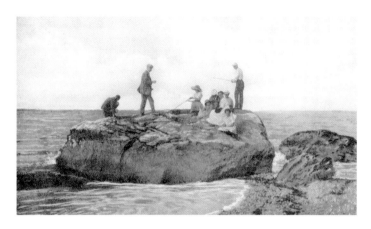

Fishing from a rock at Orient Point Inn. Many vacationers would spend part of their days fishing near the Orient Point Inn. It was both recreational and practical. The inn was situated across from the Cross Sound Ferry and burned down years ago. *Courtesy of the Whitaker Collection at the Southold Free Library.*

Water, Water, Everywhere

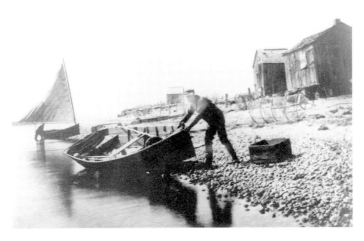

Two fishermen are preparing to set off for a day of work, with shacks to the right. Often, fishermen spent six days a week in the shacks so that they could devote most of their time to their work. *Courtesy of the Shelter Island Historical Society.*

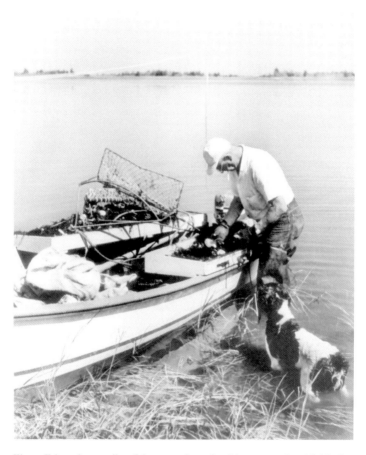

Elmer Edwards, a scallop fisherman, is getting his gear ready, with his dog at his side, to set off from Coecles Harbor on Shelter Island for a day of dredging for scallops. *Courtesy of the Shelter Island Historical Society.*

Water, Water, Everywhere

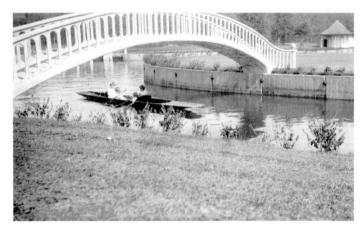

This image, taken circa 1910, is of the wife of Francis X. Smith, the "Twenty Mule Team Borax King," and her children, who are in an English punt boat under a bridge in their Japanese garden and lagoon built on their estate, *Presdelieu*, on Shelter Island. *Courtesy of the Shelter Island Historical Society.*

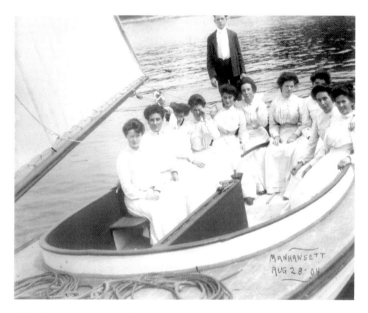

This picture shows a typical pastime at the Manhanset Hotel, on Shelter Island, on August 28, 1904. The women were dressed in white and would be passengers, not sailors, going out for a sail on a sunny summer day. In 1871, the Shelter Island Association realized the potential of the island for use as a summer resort. It had the odorous bunker fish factories moved and contracted to have hotels and cottages built to attract tourists. *Courtesy of the Southold Historical Collection.*

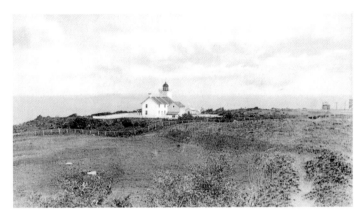

Horton's Point Lighthouse. This image offers an early glimpse of the building. Even though President Washington commissioned it in 1790, it was not built until 1857 because more land was needed. The rest of the land was finally acquired in 1855. Its first Fresnel lens was powered by whale oil. Today, the building houses a museum in Southold. *Courtesy of the Southold Historical Society.*

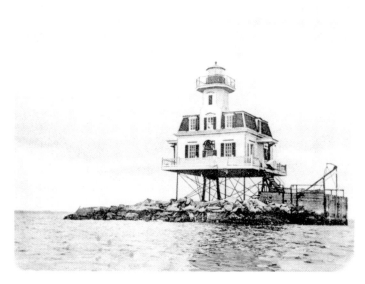

Long Beach Bar Lighthouse greets sailors at the entrance to Greenport Harbor, circa 1906. It is located near Long Beach Point, off Gardiners Bay. It was built in 1870, and its unusual screw pile construction was plagued by ice that threatened its foundation. More stone was added to the base, but it still had problems. It is also called "Bug Light" because of its bug-like appearance. *Courtesy of the Whitaker Collection of the Southold Free Library.*

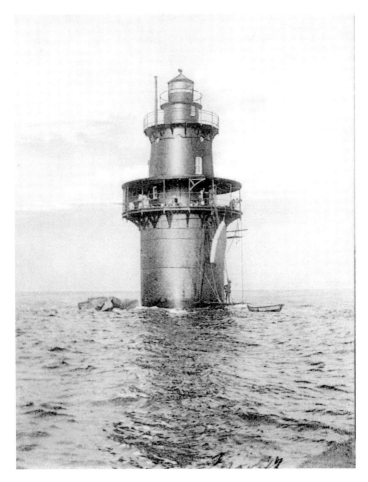

Orient Point Lighthouse can be seen through Plum Gut, between Long Island Sound and Gardiners Bay. This postcard photo was taken circa 1905. Today, passengers on the Orient Point ferry traveling to New London, Connecticut, are able to see the lighthouse when they pass by. *Courtesy of the Whitaker Collection of the Southold Free Library.*

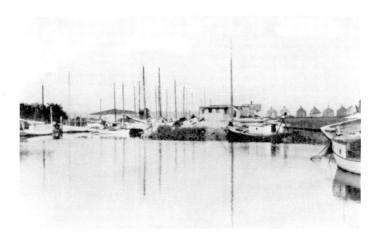

The scallop fleet at anchor in New Suffolk, Long Island. This area drew many fishermen to the water to make a living. In 1873, boats from New Suffolk, Greenport, East Marion and Sag Harbor were shipping about five thousand bushels of scallops to New York City. By 1895, two hundred crafts were working the scallop fields. At one time, the North Fork produced the largest supply of scallops in the country. Unfortunately, the 1938 hurricane destroyed many of the scallop beds. *Courtesy of the Cutchogue New Suffolk Library.*

Water, Water, Everywhere

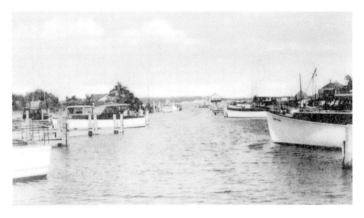

A fishing fleet, New Suffolk, Long Island. This postcard shows fishing boats interspersed with pleasure crafts at a marina. Butterfish, flounder, porgies and especially weakfish were plentiful in these waters in the 1930s and '40s, allowing commercial fishermen to make a living. *Courtesy of the Cutchogue New Suffolk Library.*

From Potatoes to Grapes

This document shows a page in a pamphlet of a premium list of the Southold Town Floral and Agricultural Exhibit of selected fruit and vegetables on display on June 16, 1880. The annual gathering began in 1877 and lasted many years. *Courtesy of the Whitaker Collection of the Southold Free Library.*

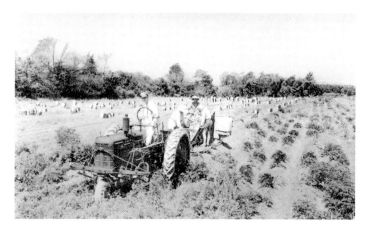

Digging Long Island potatoes, Cutchogue, Long Island. Potatoes and cauliflower were the major crops grown on Long Island from the 1800s until the 1980s. This image shows workers collecting the potatoes. Both crops are still grown today but not to the extent that they once were. In addition, a variety of vegetables and fruits, such as cabbage, Brussels sprouts, broccoli, tomatoes and corn, as well as apples, peaches and strawberries, is offered for sale at farm stands. *Courtesy of the Cutchogue New Suffolk Library.*

From Potatoes to Grapes

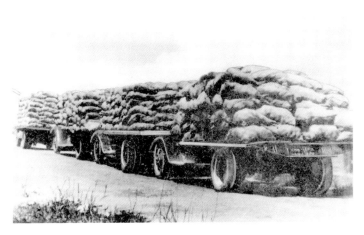

Potatoes, Orient's major crop, Orient, Long Island. Bushels and bushels of potatoes are piled high on trucks to be brought to market. In 1945, seventy-two thousand acres of farmland were devoted to growing potatoes in Nassau and Suffolk Counties. *Courtesy of the Cutchogue New Suffolk Library.*

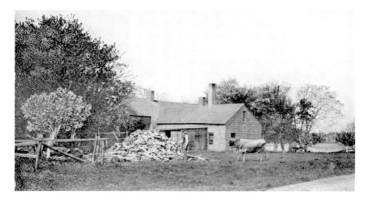

Bill Laury's old homestead, Southold, New York, circa 1900. This postcard reveals what a typical work area on a farm would look like. A cow is moving about, ready to graze, and a woodpile is standing by for the people in the farmhouse to use as firewood. *Courtesy of the Whitaker Collection of the Southold Free Library.*

From Potatoes to Grapes

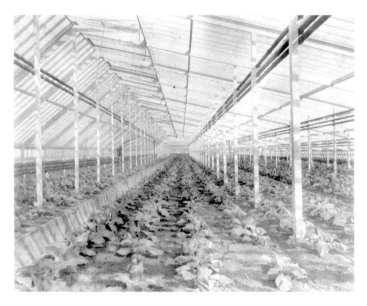

This picture shows tobacco plantings in a very large shed that would be called a greenhouse today. Tobacco was another crop grown and harvested on the East End. *Courtesy of the Frank F. Hartley Collection of the Southold Historical Society.*

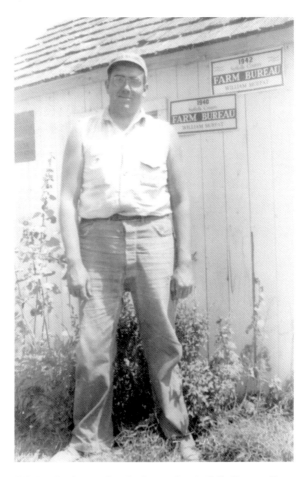

Bill Moffat is standing in front of a Suffolk County Farm Bureau sign on his farm in Southold. He must have been a proud member of the organization, as it had a reputation for helping farmers improve their agricultural methods. Today, it is called the Long Island Farm Bureau. *Courtesy of the Southold Historical Society.*

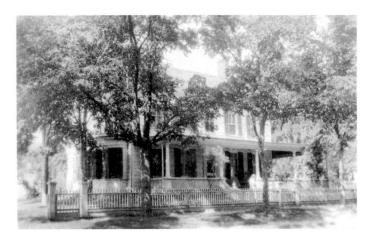

Old Orchard Farm, the Jennings' home, circa 1907. The Jonathan Jennings family constructed this house in 1761. The land included a one-and-a-half-story wood-frame building with a center chimney, as well as a barn, privy and scattered outbuildings. *Courtesy of the Whitaker Collection of the Southold Free Library.*

John Howell Farm, called "the Old House." This double Cape Cod home was built in 1827 on South Harbor Lane. It was kept in the family for almost 135 years. This farm is unique in that its owners kept the original farm buildings in good shape for all those years. *Courtesy of the Whitaker Collection of the Southold Free Library.*

From Potatoes to Grapes

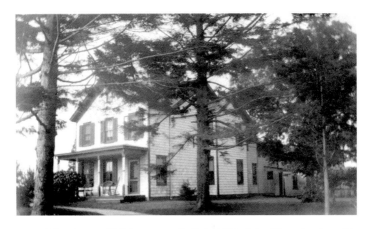

Howell farmhouse. This house was built in 1890. It is still used today with one of the farm buildings. The house is part of the Croteaux Vineyard and Tasting Barn. *Courtesy of the Whitaker Collection of the Southold Free Library.*

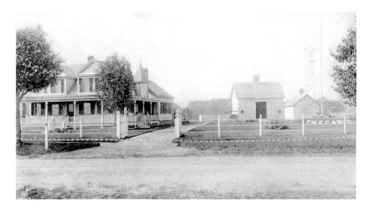

The Gables, Southold, New York, 1910. This farm on Bayview Road was typical of the era, with a large home on one end and the farm buildings on the other side. The farm was named by the family who owned it, the Carls. *Courtesy of the Whitaker Collection of the Southold Free Library.*

From Potatoes to Grapes

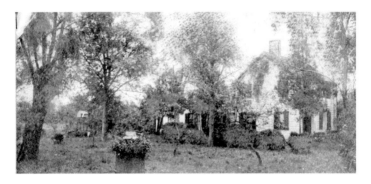

The oldest house in Southold, the Youngs Home. John Youngs, one of the town's early settlers, built this house in 1660, but the land purchase was recorded as 1656. It is still standing on the road named after its owner in Southold. *Courtesy of the Whitaker Collection of the Southold Free Library.*

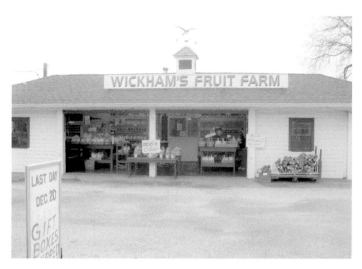

Wickham's Fruit Farm, Cutchogue, Long Island. The Wickhams are one of the oldest farm families in the area. This farm stand is a landmark for people visiting for the day. It sits on Route 25, proudly displaying fresh fruits, vegetables, jams and baked goods from April through December. The stand began with vegetables placed on a field wagon at the end of a tractor, and eventually a garage was built in the 1960s as a more permanent structure. It is open every day except Sunday. *Photo by the author.*

From Potatoes to Grapes

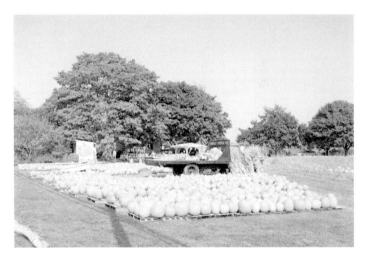

Krupski's Pumpkin Farm, Peconic, Long Island. This postcard shows a variety of pumpkins, for which the farm is known. This family is also an old farm family here on the North Fork. Today, a building with garage doors houses the operation. Fruits, vegetables and jams are also sold here. Its signature sign is a large reflective pumpkin on the side of a barn that can be seen at night as people drive by. *Courtesy of the Cutchogue New Suffolk Library.*

Pindar Winery. Pindar, named after an ancient Greek poet, has been around since 1979, the oldest winery under the same family ownership. Dr. Dan Damianos, who runs it with his three sons, started the operation as a small venture with only 30 acres. Today, it is the largest of all the wineries, with 550 acres. *Photo by the author.*

From Potatoes to Grapes

Lenz Winery. This winery began in 1978 using one of the Krupski family potato barns as its tasting building. It has seventy acres of the finest grapes, including chardonnay, merlot and cabernet sauvignon. *Photo by the author.*

Castello di Borghese Winery. This establishment originally belonged to Alex and Louisa Hargraves, pioneers in this area for the winemaking industry. They thought that the soil and climate were best suited to winemaking and bought a potato farm, where they began planting grapes. It took years of sweat and hard work to produce a crop that would eventually become a viable business. They proved the naysayers wrong and spearheaded an industry that includes over thirty wineries today. The Borghese family purchased the winery in 1999 and continue to expand the operation. *Photo by the author.*

ISLANDS OF PARADISE

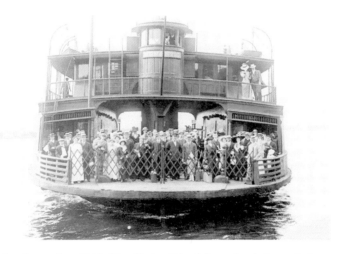

A ferryboat, circa 1900. The Shelter Island ferry shuttled people from Greenport to Shelter Island Heights on the North Ferry. It was the only way to get to Shelter Island unless you had a private boat. Many of the travelers would wear their Sunday best, heading to one of the inns or hotels to escape the summer heat of the city. *Courtesy of the Shelter Island Historical Society.*

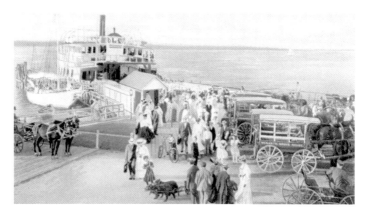

This postcard beautifully depicts a scene of the comings and goings of the travelers to Shelter Island at the ferry in Shelter Island Heights, circa 1900. Men with carriages and horses are shuttling passengers for the local hotels. The children are enjoying the activity. *Courtesy of the Cutchogue New Suffolk Library.*

Islands of Paradise

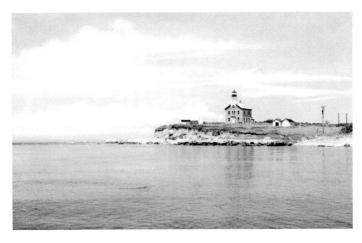

Plum Island Lighthouse, located two miles off the tip of Long Island. The area is filled with bluefish, weakfish and other varieties. In 1826, Richard Jerome sold three acres to the United States government to be used for a lighthouse. In 1954, the island was renamed Plum Island and has been serving as an animal research facility since then. It is only accessible by government ferry. *Courtesy of the Whitaker Collection of the Southold Free Library.*

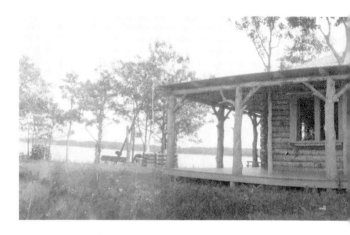

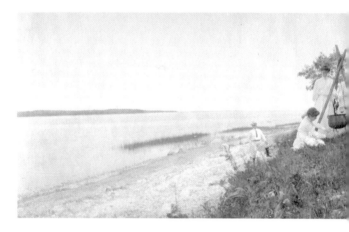

Top image: A log cabin on Cedar Island, circa 1904. This very small island used to be called Taylor Island and was owned by the F.M. Smith family as part of their estate. This log cabin was used to house clambakes for festive summer occasions. The structure was built in 1900 on the northeast part of the island. *Courtesy of the Shelter Island Historical Society.*

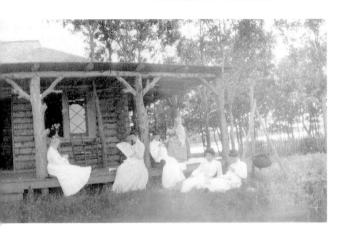

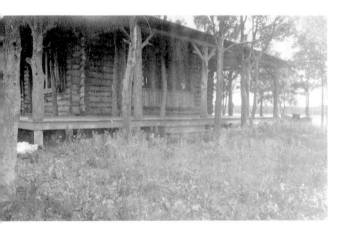

Bottom image: Smith family members, of Borax fame, are sitting at the log cabin for a picnic. The island is now called Taylor's Island Park and is owned by Shelter Island. It is enjoyed by Shelter Islanders throughout the warmer months. *Courtesy of the Shelter Island Historical Society.*

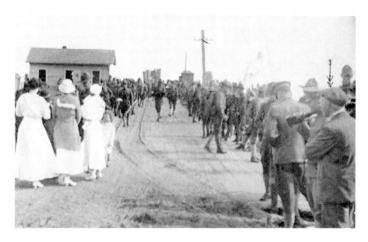

In 1897, the United States government bought 130 acres on this island to build Fort Terry to be used as a defense position in the Spanish-American War. Later, it was used to train troops to prepare them for our fight in Europe. In this postcard, the first military contingent is shown leaving to fight in France in 1918. *Courtesy of the Cutchogue New Suffolk Library.*

Islands of Paradise

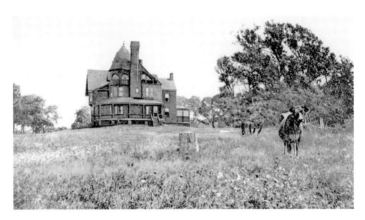

Gun Club House, Robins Island, Long Island. It is fitting to include this picture, as shooting and hunting is what this island has always been known for. In 1884, it had the finest game preserve in the country. Pheasants, quail, wild turkeys and other game were hunted. Fields of wheat, rye, buckwheat and corn were planted to feed the animals. Over the years, there were many owners who kept the island private. In 1993, Louis Bacon, a financier from North Carolina, bought the island and worked with the Nature Conservancy to limit development of the island in the future. *Courtesy of the Cutchogue New Suffolk Library.*

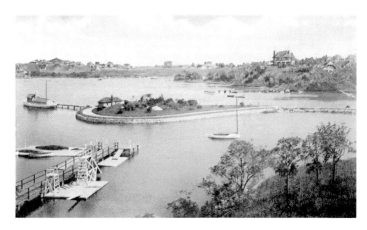

Little Hay Harbor at Fishers Island. Even though this island is two miles south of Connecticut and eleven miles to the northeast of Orient, it became a part of Suffolk County, New York, and Southold Town in 1879. This postcard shows why it drew a large number of summer people to enjoy the water views and boating activities. Today, it has a small year-round population that swells in the summer months. It is accessible by ferry only from New London, Connecticut, or by private boat. *Courtesy of the Cutchogue New Suffolk Library.*

Islands of Paradise

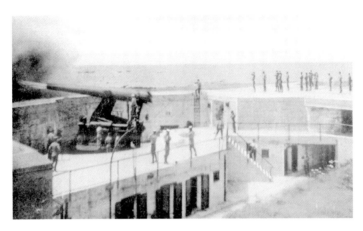

Fort Wright firing of the large guns, Fishers Island, New York. This postcard gives a glimpse of the training area of the island. In 1898, it became Fort H.G. Wright to serve as a coastal defense project. Years before, the island had sustained a small farming community, as well as a brick-making industry due to the large amount of clay found here. A Coast Guard station was established here in 1870, and Race Rock Lighthouse was built in 1878. *Courtesy of the Southold Historical Society.*

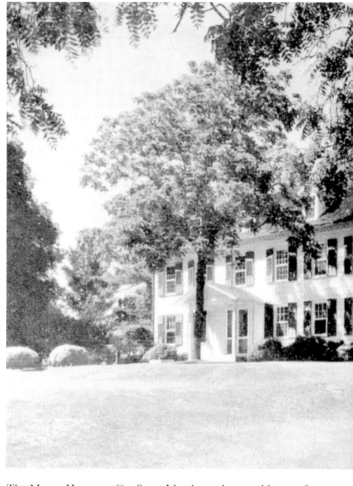

The Manor House on Gardiners Island was the grand home of the Gardiner family until 1947, when it burned down. It was rebuilt later in brick in a similar style. It is the oldest family-owned real estate in America and has been kept private. In the 1600s, it

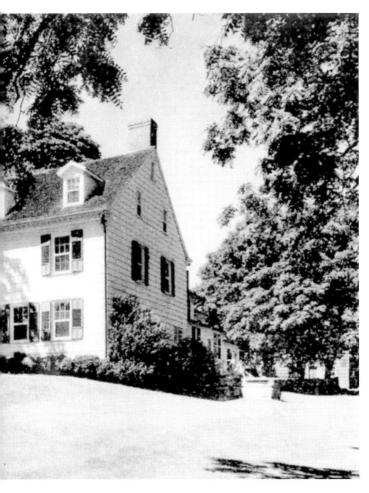

was set up as a plantation, where corn, wheat, fruit and tobacco were grown. Sheep and cattle were raised here as well. Today, it has a large colony of ospreys and the largest stand of white maple in the Northeast. *Courtesy of the East Hampton Historical Society.*

Daily Life

BRIGHTEN UP

Tasty Wall Paper makes a home look new, bright and cheerful. The biggest improvement in the home, for the least money, can be made by the use of a tasty Wall Paper.

Taste in Wall Paper does not mean expensive paper at our store. We can supply you with good Wall Paper of tasty design at prices that are surprisingly cheap. We invite you to look at our samples.

Remember that PUTNAM FADELESS DYES produce the fastest and brightest colors of any known package dye.

G. A. GOULD, Merchandise, Cutchogue, N. Y.

This postcard displays a drawing of an advertisement of the sale of wallpaper for the G.A. Gould Store in Cutchogue, circa 1900. It gives us a look at how shopping in small stores was handled in the local hamlets. *Courtesy of the Cutchogue New Suffolk Library.*

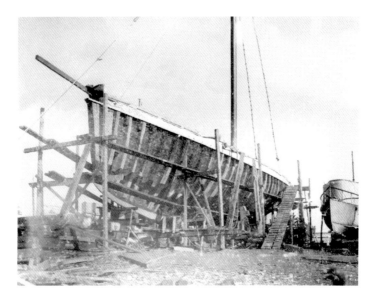

The village of Greenport has a deep-water port that helped it become a major shipbuilding and whaling center between 1795 and 1859. Fishing for many types of fish, including menhaden or bunker, had been a popular activity here since colonial times. Later, when whaling fell off in 1881, it became a center for menhaden fish factories, which provided fertilizer for farmers and oil for paint. In addition, harvesting oysters was a major industry from 1900 until the early 1960s. *Courtesy of the Frank K. Hartley Collection of the Southold Historical Society.*

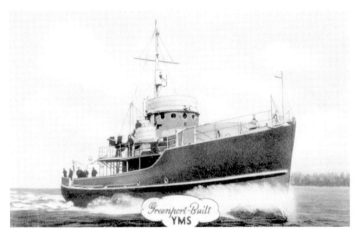

The Greenport Basin and Construction Company was famous for building minesweepers, landing craft and tugboats used by the United States Navy in World War II. The shipyard had two shifts a day during the week and also operated on weekends during that time. Previously, it had built ships for both the Russian and United States navies. *Courtesy of the Floyd Memorial Library in Greenport.*

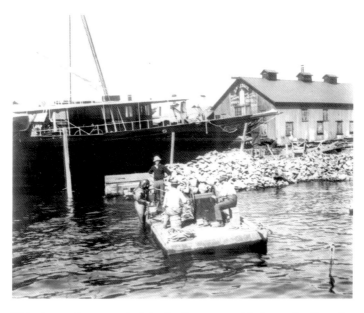

This picture shows a typical day in Greenport, with the overhauling of a boat in which a diver was needed for part of the repair. *Courtesy of the Frank K. Hartley Collection of the Southold Historical Society.*

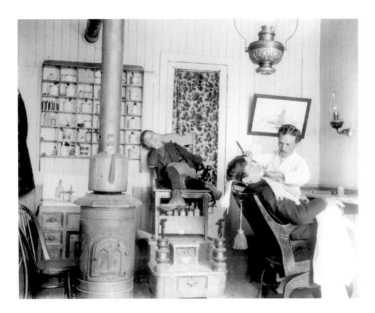

Sam Mazzo's barbershop. This photo gives us a look at the interior of a barbershop, circa 1900. A young patron is resting while waiting for his turn. In the meantime, all of the wares of the barber are prominently displayed on open shelves. The wood-burning stove is close by for warmth. *Courtesy of the Frank K. Hartley Collection of the Southold Historical Society.*

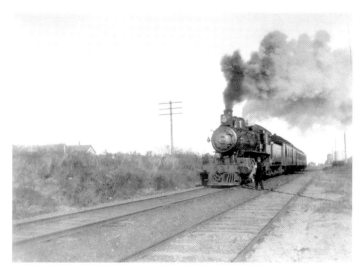

This image depicts Engine #214 pulling a train, with large tanks in the distance. The Long Island Rail Road built a link between Manhattan, the rest of Long Island and Greenport in 1844. Service began in 1846. This not only helped with moving crops and cargo, but it also allowed for many people to travel to the East End to enjoy resort life. *Courtesy of the Frank K. Hartley Collection of the Southold Historical Society.*

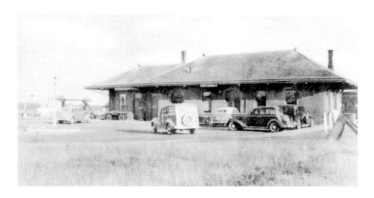

Long Island Rail Road station, Greenport, Long Island. This postcard shows us what the Greenport station looked like all those years ago, circa 1940. The station was located near the ferry so that tourists could easily get to Shelter Island as a final destination. It was the end of the Ronkonkoma Line. *Courtesy of the Cutchogue New Suffolk Library.*

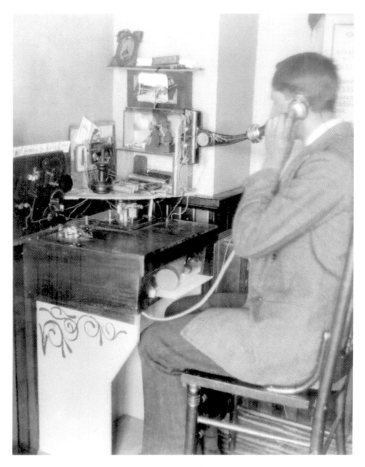

How wonderful and exciting it must have been when people first used their telephones. Frank Hartley is seen here using the phone, a very new technology at the time. He is credited with experimenting with using telephone circuits before service was offered in Greenport. The first telephone in the area was installed in the home of Dr. Ireland in 1896.
Courtesy of the Frank K. Hartley Collection of the Southold Historical Society.

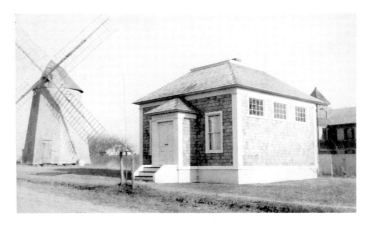

This windmill was built in 1810 in Southold by Nathaniel Domini and was moved by barge to Shelter Island, where it was restored. Later, it was used to grind corn, wheat, buckwheat and rye for farmers. Mills were a gathering place for villagers because they had to wait for their grain to be milled. To pass the time, they traded gossip, news and stories. The windmill was later moved close to the Shelter Island Library. *Courtesy of the Shelter Island Historical Society.*

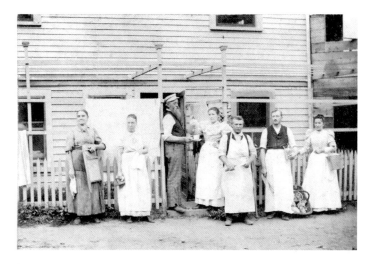

Meinhardt Hotel. This image shows the owner, George Meinhardt, bearded, being served coffee by his restaurant staff. Also included in the picture are a cook and laundress who worked for him. Today, the building stands as a similar establishment under a different name, the Old Country Inn. *Courtesy of the Shelter Island Historical Society.*

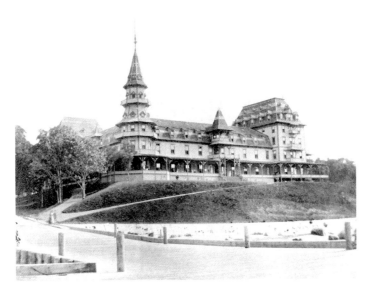

Manhanset Hotel. In 1866, a group of men formed the Shelter Island Grove and Camp Meeting Association of the Methodist Episcopalian Church. They bought land in the Shelter Island Heights area with the idea of building a church, hotels and cottages. They had the fish factories moved because of the odorous smell caused by heating bunker or menhaden in order to remove the oil. This hotel was built in 1873 to accommodate the burgeoning summer crowds. It was built in the grand style of the times. Unfortunately, it was partially destroyed by fire in 1890 and rebuilt in 1897. It was destroyed again by fire in 1910. *Courtesy of the Shelter Island Historical Society.*

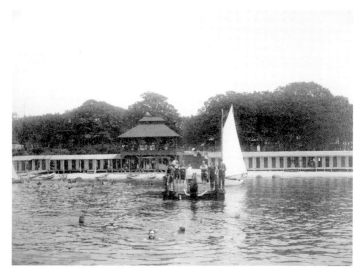

Manhanset pavilion and dock. This image shows the reason why so many tourists chose to spend time here in the summer months. There were beautiful beaches, with swimming and hotel amenities as part of the accommodations. *Courtesy of the Shelter Island Historical Society.*

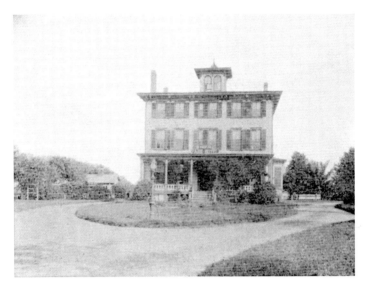

Kreutzers Park Hotel. This postcard shows a building that was constructed circa 1860 and was owned by Ferdinand and Matilda Kreutzer until 1915. It was situated near Route 25. It served as a summer resort establishment for people who wanted to escape the heat in Manhattan. Later, Robert Lang bought the place and altered the house to use it as a private residence. He also had the structure moved closer to the bay. Today, the farm and vineyard are still in the family and are called "the Old Field." *Courtesy of the Cutchogue New Suffolk Library.*

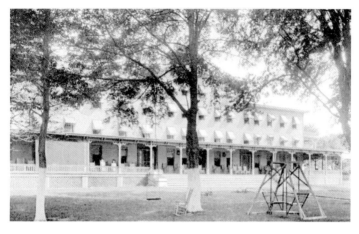

Orient Point Inn. This postcard depicts a famous hotel that was built in 1796. It boasted several luminaries among its guests, such as Grover Cleveland, Walt Whitman and James Fenimore Cooper, who wrote *The Sea Lions* while in Orient. The building no longer exists. *Courtesy of the Cutchogue New Suffolk Library.*

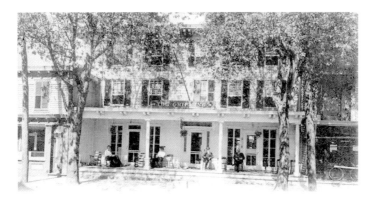

The Griffing Hotel, Greenport, 1910. This hotel on Front Street was one of many at the turn of the century and later to attract summer visitors. It was formerly the Greenport Hotel, circa 1902, and changed names over the years. Greenport's proximity to water and its location at the end of the Long Island Rail Road line tempted many people to summer here. *Courtesy of the Cutchogue New Suffolk Library.*

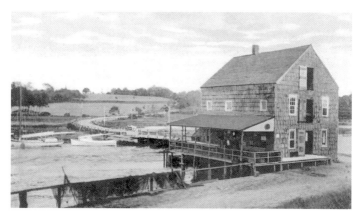

The Old Mill, Mattituck, Long Island. This mill was a gristmill when Samuel Cox built it in 1820. It used the incoming tide to force open the gates; when the tide receded, the gates closed and an auxiliary gate opened through a tunnel, turning the mill. Farmers brought grain to be ground into flour. Today, it is a popular restaurant known for using local produce in its meal preparation. *Courtesy of the Cutchogue New Suffolk Library.*

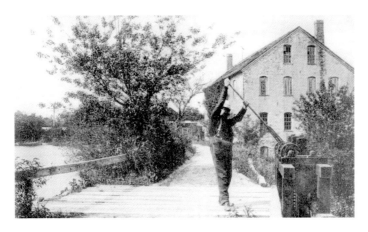

The floodgate and dam at Upper Mills Riverhead, Long Island. This postcard shows the water-powered mill that became a small power plant generating electricity used to grind grain and cut logs for the locals. Ice was cut and transported from the nearby millpond to be used on farms before mechanical refrigeration. *Courtesy of the Cutchogue New Suffolk Library.*

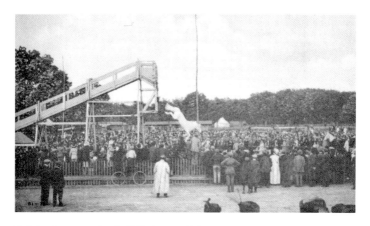

Driving horses at the Suffolk County Fair in 1914. County fairs were great meeting places for families every year. Horse racing, using trotters, was a good draw, as were the farm contests for the largest vegetables and the best recipes. *Courtesy of the Whitaker Collection of the Southold Free Library.*

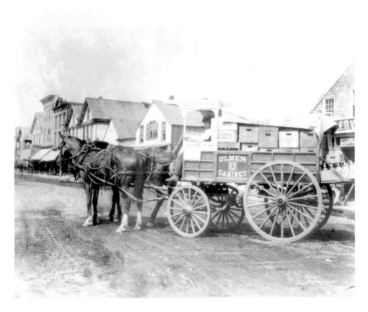

D.C. Petty beer wagon in Greenport, circa 1900. David C. Petty owned a saloon and managed an icehouse in the winter. In order to accommodate the many summer visitors, this common sight would have been visible near all of the hotels and other eating establishments in Greenport. *Courtesy of the Frank K. Hartley Collection of the Southold Historical Society.*

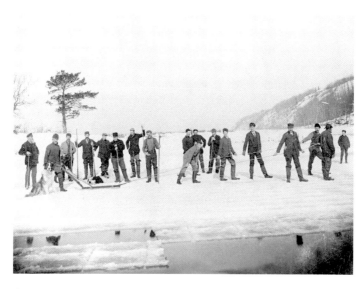

Cutting ice at Wicks Pond in Shelter Island, February 1, 1897. Cutting ice was a very important job in those days because it was one of the few ways to preserve food. Often, ponds were used because clear water was in demand for ice. The ice was stored in icehouses on farms and surprisingly lasted many months. *Courtesy of the Shelter Island Historical Society.*

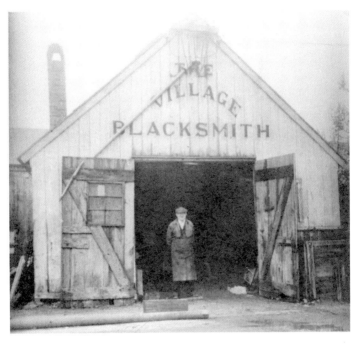

The village blacksmith in Greenport, circa 1930. The village "smithy" was an important person in every town. He made iron tools for the farmer, using fire, an anvil and a hammer. Shoeing horses was another job performed by the blacksmith until the automobile came on the scene. *Courtesy of the Cutchogue New Suffolk Library.*

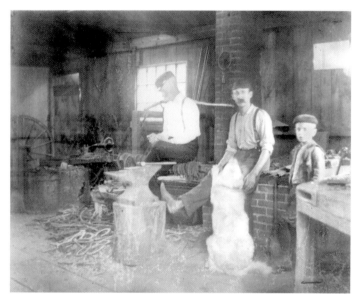

Blacksmith Bunce on Adams Street in Greenport. This picture shows the inside of a shop, with two men preparing for work. One could be a "striker," or apprentice, who would swing the sledgehammer and hit the area on the metal that the blacksmith indicated. *Courtesy of the Frank K. Hartley Collection of the Southold Historical Society.*

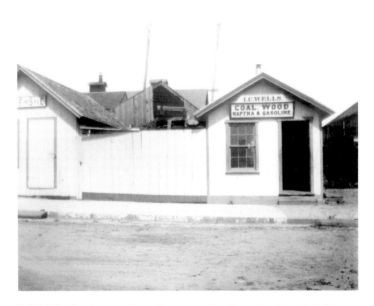

I.C. Wells. People were dependent on coal and wood to heat their homes. This establishment was in Greenport, near boats that would deliver the coal. Later, drivers would be sent to customers' homes, where they would use a chute to move the coal from the wagon through a window and into the basement. There, a large bin would act as a receptacle. *Courtesy of the Southold Historical Society.*

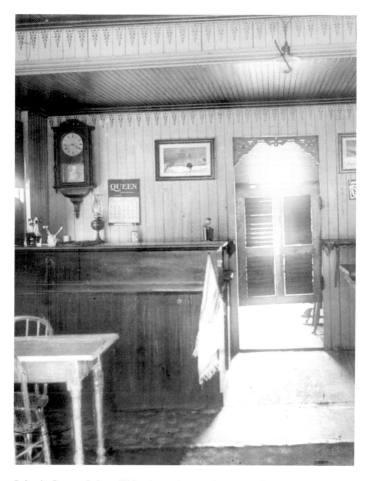

Salter's Oyster Salon. This photo shows what a small eatery would have looked like. This one in Greenport specialized in offering meals of oysters and other seafood from the local waters. Greenport was a major harvester of oysters from 1900 to the early 1960s. *Courtesy of the Frank K. Hartley Collection of the Southold Historical Society.*

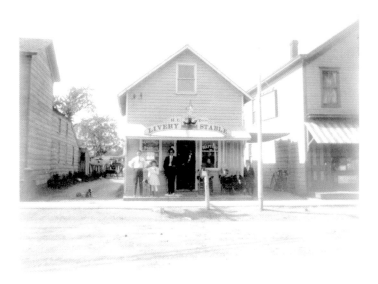

H.E. Young livery stable. Horses were kept here for hire during the year and in the summer for tourists. It was so popular in the summer that one had to reserve a carriage and horse ahead of time on Sundays. *Courtesy of the Frank K. Hartley Collection of the Southold Historical Society.*

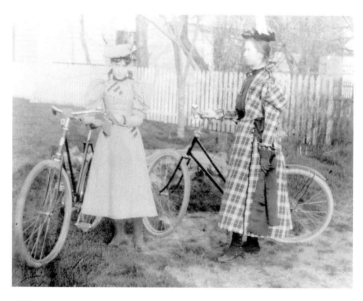

This picture depicts not only the fashion of the time for women but also shows how ladies would spend a Sunday afternoon. Bicycling was a favorite pastime for people back then, especially in Greenport. *Courtesy of the Southold Historical Collection.*

Daily Life

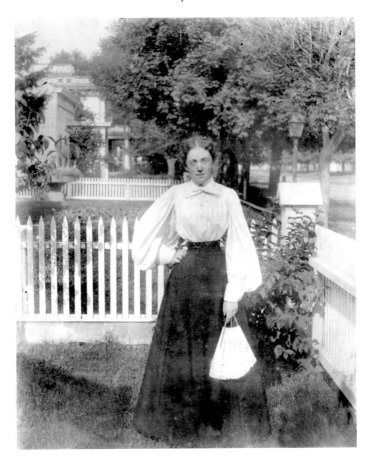

This woman is standing in her front yard, near a white picket fence, wearing a white shirtwaist with full sleeves, a long black skirt, belted, and holding a white handbag. Her outfit depicts the fashion of the day. *Courtesy of the Frank K. Hartley Collection of the Southold Historical Society.*

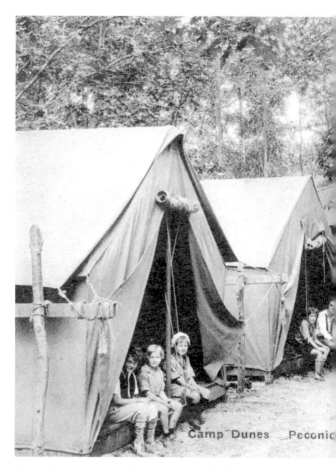

Camp Pinecrest Dunes, Peconic, Long Island, circa 1931.
Children sitting outside of tents, enjoying their stay at Camp
Pinecrest Dunes, are pictured on this postcard. W. Thomas
Ward opened the camp in 1931. It was located near Great
Pond on Soundview Avenue. Many activities were offered
to the children who attended, such as swimming, boating,

g Island, N. Y.

diving, horseback riding and crafts, to name a few. It remained private until 1970, when it became a part of Suffolk County. Today, it is the site of Peconic Dunes County Park, which offers environmental educational programs and a summer camp. *Courtesy of the Cutchogue New Suffolk Library.*

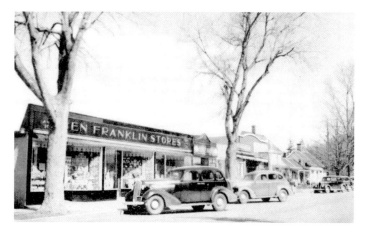

This postcard of Main Street, Cutchogue, shows cars parked in front of a Ben Franklin Five and Dime, circa 1937. These types of stores were found in many small towns, offering discounted prices on many everyday items, such as fabric, sundries and seasonal goods. *Courtesy of the Cutchogue New Suffolk Library.*

EARLY SETTLERS

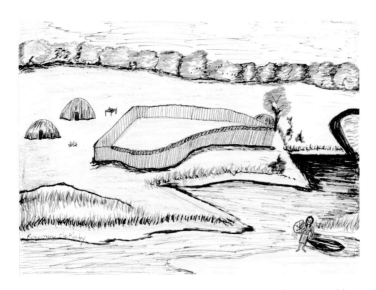

This is a rendition of Fort Corchaug by the author, using as a guide a painting by Audrey Watson Wigley found in the Southold Indian Museum. The town of Cutchogue took its name from the Indian name *Corchaug*, which means "the great place." These native peoples were here long before the Dutch and English came upon the area. The settlement was located near water so that members of the group could collect shellfish, which was plentiful, and hunt for meat. On the left are two summer wigwams, covered by flat grasses for protection, that were used as homes. The remains of the settlement are found in the Downs Farm Preserve today. *Author's collection*.

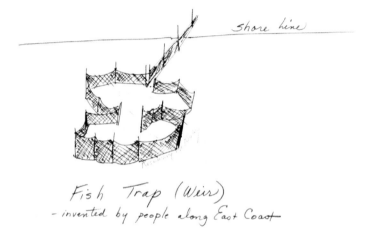

shore line

Fish Trap (Weir)
- invented by people along East Coast

This is a drawing by the author depicting a fish weir or trap used by Native Americans. Stakes were placed in the middle of a stream near a coast. Plant material was then wrapped around and between the stakes to prevent the fish from escaping. The fish were then herded into the trap, where the fisherman could later extract them. Similar traps have been used by fishermen ever since. *Courtesy of the Southold Indian Museum.*

Early Settlers

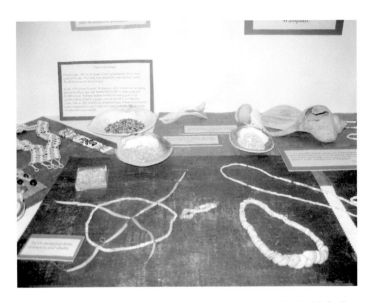

This photo of a wampum display was taken at the Southold Indian Museum. Fort Corchaug was a wampum-producing settlement. Squaws and braves wore strings of wampum as adornment and as evidence of their wealth. Wampum was also given as atonement for a crime. White beads were made from whelk shells that were plentiful on the area's beaches. The purple and black beads were in greater demand because they were more difficult to fashion into beads. *Courtesy of the Southold Indian Museum, owned and operated by the Incorporated Chapter of New York State Archeological Association.*

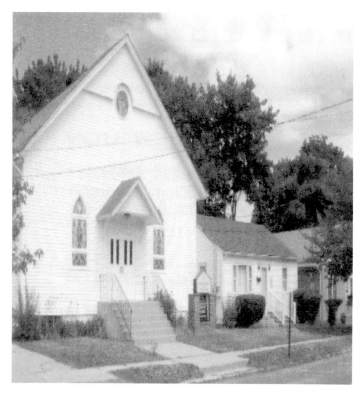

The Clinton AME African American Church in Greenport was one of the first churches built by the African American community, in 1924. This church branched off from the Asbury Methodist Church in the Wall Street area of New York City and considered itself the Freedom Church. The leaders were African American business owners, farm workers and domestics. *Courtesy of the Clinton AME African American Church in Greenport.*

Early Settlers

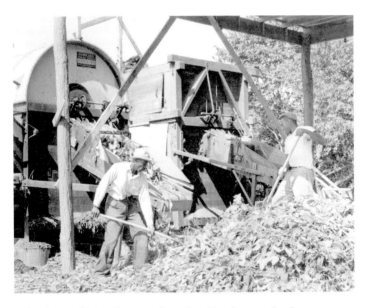

This picture depicts farm workers shoveling harvested tobacco onto a conveyor belt. African American farm workers were a necessary part of the agricultural community for many generations. *Courtesy of the Southold Historical Society*.

Wayland Jefferson was born in 1884 in Southold and was educated at Columbia University. He became the first official town historian, serving from 1931 until 1962, and was well known as a leading expert on colonial history of the North Fork. He gave many lectures on the subject and wrote a book, *Cutchogue, Southold's First Colony*. *From* Old Southold Town's Tercentenary *by Ann Hallock Curie-Bell.*

Unique Architecture

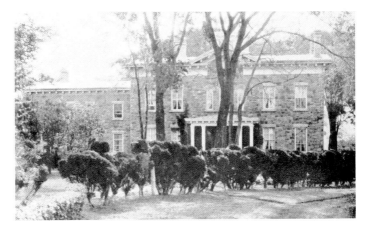

Brecknock Hall. This beautiful structure was built as the family residence of David Geiston Floyd, whaling and ships' chandlery entrepreneur and grandson of General William Floyd, one of the signers of the Declaration of Independence. Brecknock was aptly named as a tribute to the family's ancestral home in Wales. This home was designed in the Italianate architectural style of the time and took six years to build. It was completed in 1857 and was constructed of the finest materials, including stone quarried by Scots masons from the one hundred acres of property on the grounds. Each of the main rooms had carved white marble fireplaces. Today, it stands in disrepair at Peconic Landing, a retirement community; however, a group of volunteers is working to restore it to its former luster. *Courtesy of the Cutchogue New Suffolk Library.*

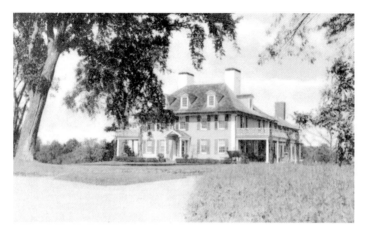

Sylvester Manor House. This postcard gives us an idea of the grandeur of the oldest home on Shelter Island. Nathaniel Sylvester owned most of Shelter Island in the seventeenth century. He owned two sugar plantations in Barbados as well. The original house was built with yellow bricks from Holland in 1735. Since they stopped growing food on Barbados because sugar was such a profitable commodity, the family began to grow vegetables and raise animals at the Shelter Island plantation. *Courtesy of the Cutchogue New Suffolk Library.*

Unique Architecture

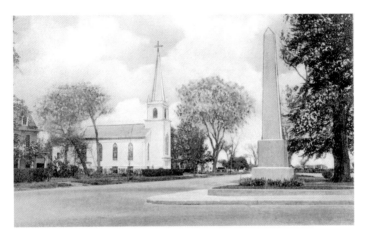

The Civil War Memorial and Congregational Church, Orient, New York. This monument honors twelve soldiers who died between 1863 and 1865 in the Civil War. It was built in 1870 and dedicated in 1875. The church that is shown here is considered the oldest Congregational church in the state. *Courtesy of the Cutchogue New Suffolk Library.*

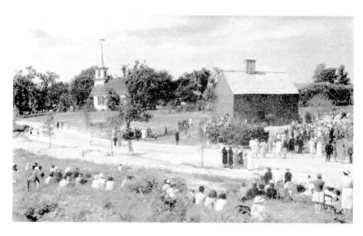

Dedication of the Old House in Cutchogue, 1940. This house was built in Southold and moved to Cutchogue in 1660. It is listed as a National Historic Landmark and dates back to 1649. It is said to be the oldest English-style frame house in New York State. It includes features of seventeenth-century architecture, such as a sitting room, leaded glass windows and a large fluted chimney. *Courtesy of the Whitaker Collection,* Tercentenary Celebration of Southold Town, *Vol. 1.*

Unique Architecture

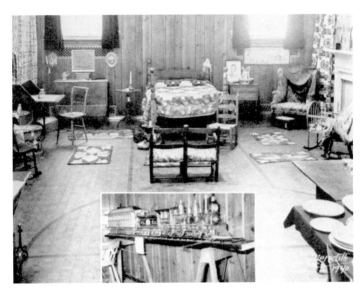

This picture shows the interior of the Old House in 1940, when it was restored. There is a sleeping area, writing area and cooking area, much like the open floor plans of today. The inset shows an antique train set. *Courtesy of the Whitaker Collection,* Tercentenary Celebration of Southold Town, *Vol. 1.*

This is a pen-and-ink drawing of the William Albertson House, circa 1752. The Albertsons, of Dutch ancestry, were the first to own this home and the last of its owners to hold slaves. The family, at various times, were farm owners, mill owners and prominent citizens of the town of Southold, producing three supervisors. *Courtesy of the Southold Historic Society* Guide to Historic Markers of the Whitaker Collection *in the Southold Free Library.*

Unique Architecture

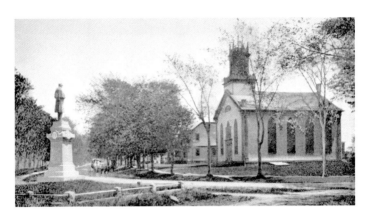

Main Street, Southold, looking east. This image gives us a glimpse of what life was like circa 1906 in Southold. The Civil War Monument is on the left and the Universalist Church is located on the curve of the Main Road. This monument was built in 1887 by the Ladies' Monumental Union to honor soldiers who died between 1861 and 1865. Many of the names listed represent families of early settlers. William D. Cochran built the Universalist Church between 1835 and 1837 in association with architect Richard Lathers in the Greek Revival and Gothic styles. It stands in the same place today. *Courtesy of the Whitaker Collection of the Southold Free Library.*

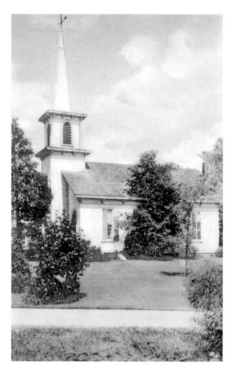

The Cutchogue Public Library, Cutchogue, New York. This postcard shows what looks like a church building; however, the history of the structure and its use is unique. The library began in 1841, according to a document signed by the Cutchogue community, with a subscription of fifty cents annually. Books were passed from home to home. In 1914, this building was rented for one dollar per year to be used as a public library. In 1917, the library was chartered by New York State and became the Cutchogue New Suffolk Free Library. Its collection was kept in the Independent Congregational Church's unused steeple. This same building dates from 1861, when there was a conflict over slavery in the Presbyterian Church. Abolitionists built another structure across the street, so this building was left empty. The library tripled in size in 1987 and was again recently expanded. *Courtesy of the Cutchogue New Suffolk Library.*

Unique Architecture

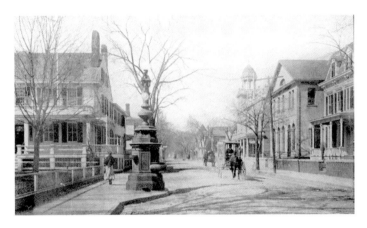

Main Street, Greenport, 1920. This image offers a view of Main Street, looking back at the Clark House and Reeve Fountain. The hotel was closed in 1927 and was later demolished. In its heyday, it played host to Walt Whitman and, before him, John Quincy Adams. In 1904, the Reeve Fountain was dedicated to Isaac Reeve (a village president who was instrumental in improving the town's water and light departments) with great fanfare, a parade, a band concert and fireworks. It was later moved to another location behind Front Street and is preserved. *Courtesy of the Whitaker Collection of the Southold Free Library.*

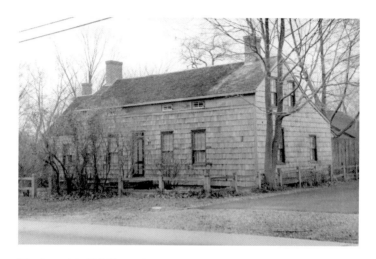

The Jeremiah Vail House is one of the oldest homes in Southold. It was built in 1656 near where St. Patrick's Church stands today. The house was later moved, first to Tuckers Lane and then to its location on the corner of Laurel Lane and the main road. Robert Lang restored it in 1953. It is a one-and-a-half-story house, like many houses of its time. *Courtesy of the Whitaker Collection of the Southold Free Library.*

Unique Architecture

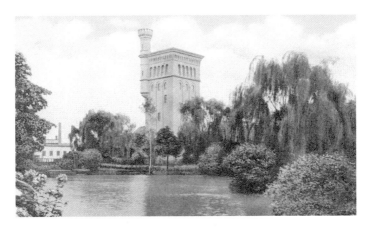

The water tower in Riverhead, 1915. This structure was built as part of Grangebel Park in Riverhead by Timothy Griffing, circa 1892. It was fashioned to look like a stone part of a European castle, even though it was built from wood. The water tower was the highest building in the area for a while, and it provided water to the community for many years. It was destroyed before World War II. *Courtesy of the Whitaker Collection of the Southold Free Library.*

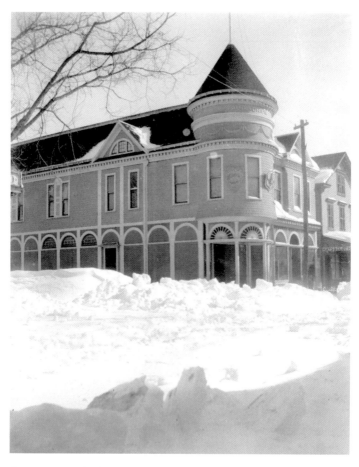

Greenport Auditorium. This building was erected in 1884 in Greenport. It was described as the most handsome public hall of its time on the East End. The first time it was used was for a presentation of Professor Moore's opera *A Dress Rehearsal*. The place was also used as a lecture hall. In 1908, it was purchased by the Odd Fellows Lodge. *Courtesy of the Southold Historical Society.*

Unique Architecture

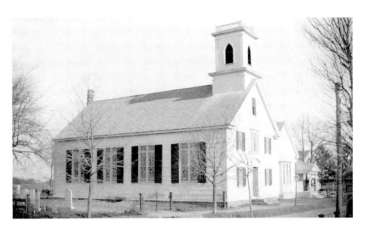

Shelter Island Presbyterian, 1900. In 1848, Daniel Lord, pastor of the Mariner Church in Boston, returned to Shelter Island and became pastor of this church. The original structure was built in 1861 and burned down in 1933. It was rebuilt in 1934 on the old site in a similar style to the old church. Reverend Nelson Chester, a former resident of Shelter Island, laid the cornerstone. *Courtesy of the Shelter Island Historical Society.*

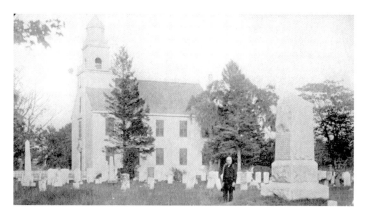

First Church and Founder's Monument, Southold, New York. This postcard shows the Reverend Epher Whitaker in front of the First Presbyterian Church in 1851. He wrote a book, *The History of Southold, Long Island: Its First Cemetery*, about the area. The original founder was the Reverend John Youngs of Southwold, England, who came with a group of Separatists, as they were called in England, or Puritans, and set up a religious community. They worshipped at a meetinghouse before the formal church was built. The present building was constructed in 1803 and was the first church to be incorporated in 1784. It joined with the Presbyterian Church of the United States in 1832. It is the oldest church society in the state of New York. *Courtesy of the Whitaker Collection of the Southold Free Library.*

Unique Architecture

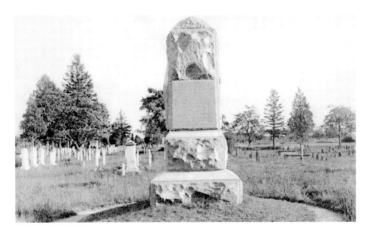

Founder's Monument, 1915. It is believed that the monument was erected on the site of the first meetinghouse. It stands at the entrance of the First Presbyterian Cemetery. *Courtesy of the Whitaker Collection of the Southold Free Library.*

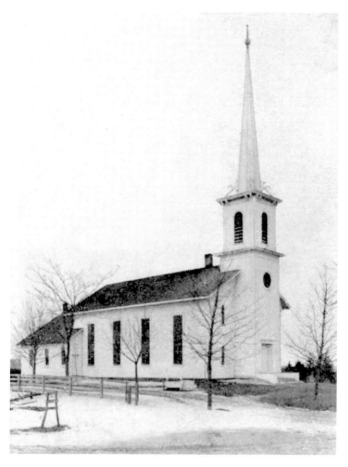

The Old Steeple Church in Aquebogue. On March 26, 1758, a religious society in Aquebogue organized the First Strict Congregational Church of Southold. In colonial history, it has been noted that many of the Puritan churches became Presbyterian and the Independent churches became Congregationalist later on. *Courtesy of the Cutchogue New Suffolk Library.*

Unique Architecture

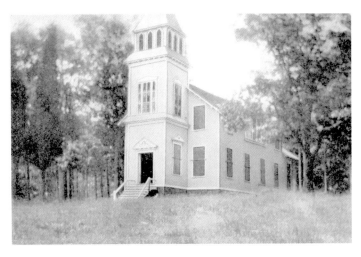

Union Chapel, Shelter Island Heights. Built in 1875, it is the oldest building on Shelter Island and is set in a natural amphitheatre, the Grove. The Shelter Island Cove and Camp Meeting Association hired Frederick Law Olmsted and Robert Morris Copeland to design this building and a resort area. This was the spot where the preacher would stand and preach to the many followers who camped out nearby, enjoying a sweeping view of both Long Island Sound and Peconic Bay. *Courtesy of the Cutchogue New Suffolk Library.*

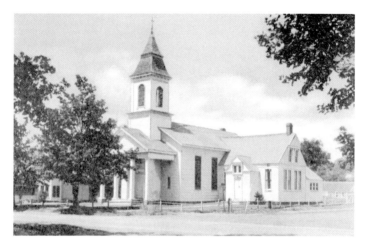

This postcard depicts the Jamesport Congregational Church, which was built in 1731 as the Jamesport Meeting House. The land was deeded by Silvanus Brown to be used only for religious purposes or it would revert back to his heirs. It was built by men in the area from six- by twelve-foot oak beams cut from the local forest. The church was founded under the leadership of the Reverend Nathaniel Mather, a descendant of the Puritan ministers of the New England Mather family. It is the oldest public building on the East End. *Courtesy of the Cutchogue New Suffolk Library.*

Unique Architecture

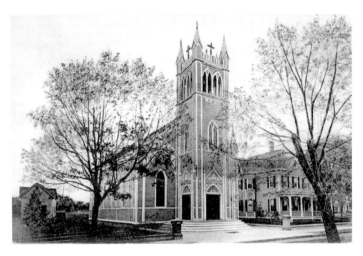

Saint Agnes Roman Catholic Church. The East End of Long Island was considered out of the way by the diocese. Although there were Catholics living here, no buildings were established until later on. As early as 1845, priests occasionally said Mass at peoples' homes. Bishop Laughlin purchased property in 1855 for a structure in Greenport, but a temporary church was used for worship. Father McCarthy was instrumental in building a temporary building. In 1883, the present structure was erected and used for Mass. Later, a bell tower, sacristy and baptistery were added. *Courtesy of the Cutchogue New Suffolk Library.*

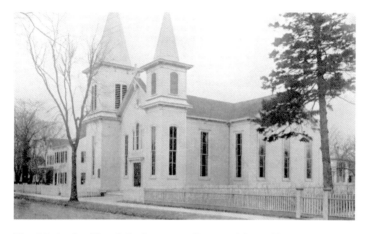

First Methodist Church in Greenport. Reverend Cyrus Foss preached the first Methodist sermon in Greenport in an old religious building erected by the Baptists in 1828. The community continued to thrive and raised money to construct a formal church, called the First Methodist Church, in 1890. It is still being used today. *Courtesy of the Cutchogue New Suffolk Library.*

Unique Architecture

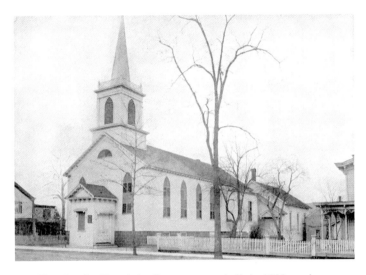

The First Baptist Church in Greenport was built in 1833 on the corner of the North Road and Main Street. In 1844, it was moved to 650 Main Street, where it still stands today. *Courtesy of the Cutchogue New Suffolk Library.*

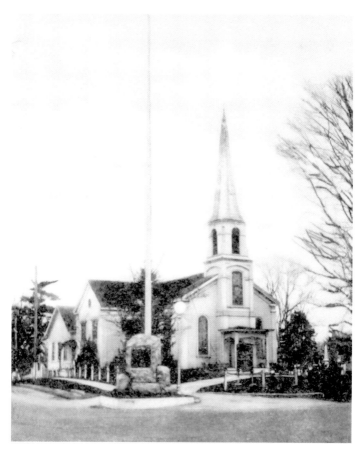

Mattituck Presbyterian. In 1715, James Reeve gifted a half acre to Mattituck's First Church. A plain meetinghouse was built on the property by his son-in-law, Nathaniel Warner. In 1852, the Reverend Joseph Parks became pastor, with the blessings of the Presbyterian Church. In 1871, O.K. Buckley of Greenport rebuilt the church, along with a steeple, and beautiful stained-glass panels were later added. *Courtesy of the Cutchogue New Suffolk Library.*

About the Author

Rosemary McKinley is a freelance writer and a former history and writing teacher. When she retired, she wanted to devote all of her energy to writing. She attended the Teachers' Institute at Columbia University in the summers of 1991 and 1992 to become a better writing teacher. That did it—she was bitten by the writing bug.

Rosemary has had an essay published online by the Visiting Nurse Association of Long Island. Another essay for Dreyfus Funds landed her a profile in the November 2006 issues of *Money* and *Fortune* magazines.

Three of her poems have been published in *Lucidity*, a poetry journal based in Texas. Another poem was published last spring in *LI Sounds*, a journal based in Southampton, New York, and one was featured in April on canvasli.com.

Last year, an article she wrote on a landmark home was published in the *Peconic Bay Shopper*.

Two of Rosemary's short stories have appeared online. The first was published on the website storiesthatlift.com.

The second was published in January in the e-zine *Long Stories Short*. Recently, one of her short stories was included in an anthology of *The Ultimate Teacher*.

Visit us at
www.historypress.net